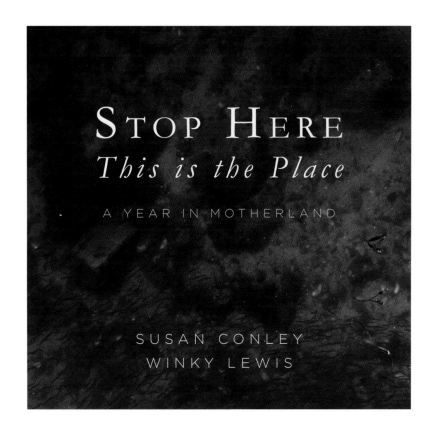

STOP HERE
This is the Place

A YEAR IN MOTHERLAND

SUSAN CONLEY
WINKY LEWIS

DownEast Books

Published by Down East Books
An imprint of Globe Pequot,
Trade division of The Rowman & Littlefield Publishing Group, Inc.
4501 Forbes Boulevard, Suite 200, Lanham, Maryland 20706
www.rowman.com

Unit A, Whitacre Mews, 26-34 Stannary Street, London SE11 4AB, United Kingdom

Distributed by NATIONAL BOOK NETWORK

Designed by Monty Lewis

British Library Cataloguing in Publication Information Available

Library of Congress Cataloging-in-Publication Data Available

ISBN 978-1-60893-620-5 (paperback : alk. paper)
ISBN 978-1-60893-621-2 (electronic)

♾™ The paper used in this publication meets the minimum requirements of American National Standard for Information Sciences—Permanence of Paper for Printed Library Materials, ANSI/NISO Z39.48-1992.

Printed in the United States of America

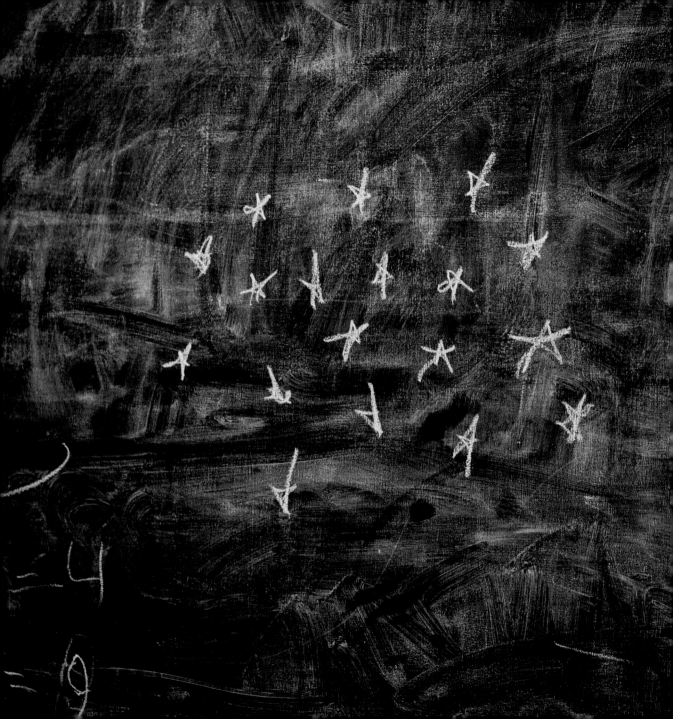

DEDICATED TO ALL FAMILIES—

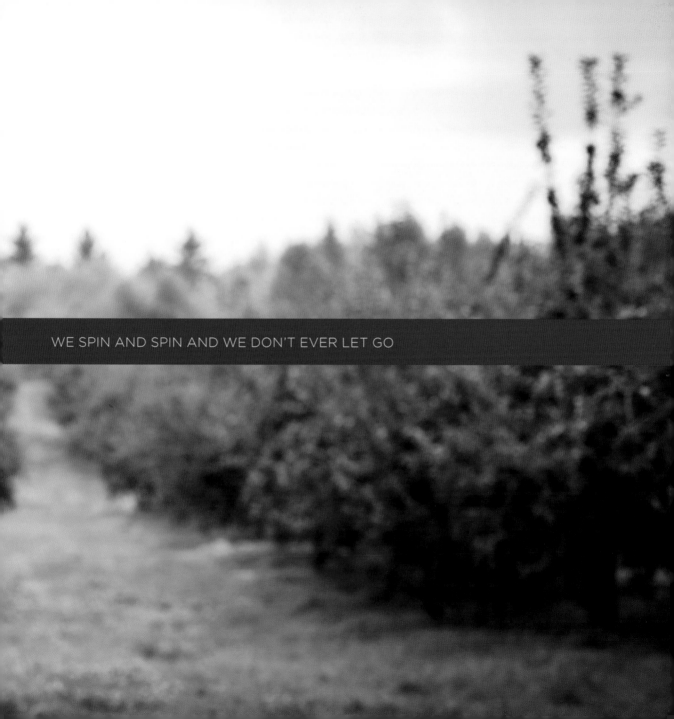

WE SPIN AND SPIN AND WE DON'T EVER LET GO

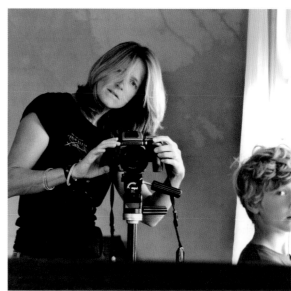

THIS IS A STORY ABOUT TWO FRIENDS —

a photographer and a writer in Portland, Maine, who tried an experiment. At the start of every week for 52 weeks Winky sent Susan a photograph, and by the end of that week Susan sent a tiny story back — a moment in time that talked to the photograph. The photographs were of their children, and the street where they all lived (only one house separated their two families), and of other green places in Maine.

The mothers saw each other sometimes dozens of times a day — exchanging kids and dogs and emergency cups of coffee, but they never spoke about their experiment. There wasn't time. Their lives often felt like they were spinning just ever so slightly out of control — like maybe motherhood was just one big race with no visible finish line.

But what happened while they weren't looking was that their experiment began to slow time down. All the little marriages of words and image said, Stop Here. Because motherhood flies by. The days are long, but the weeks are short. We know we're marking time with our kids, but how exactly? And how is it that the changes in those little bodies are so invisible, even when they're happening before our very eyes?

Stop Here, This is the Place tells the story of a year in motherland. The camera watches the children's arms and legs grow longer until any trace of baby in their faces is gone. The camera reports how long one year can feel in the life of a ten-year-old. Children look ahead. But mothers. We can always go back and remember.

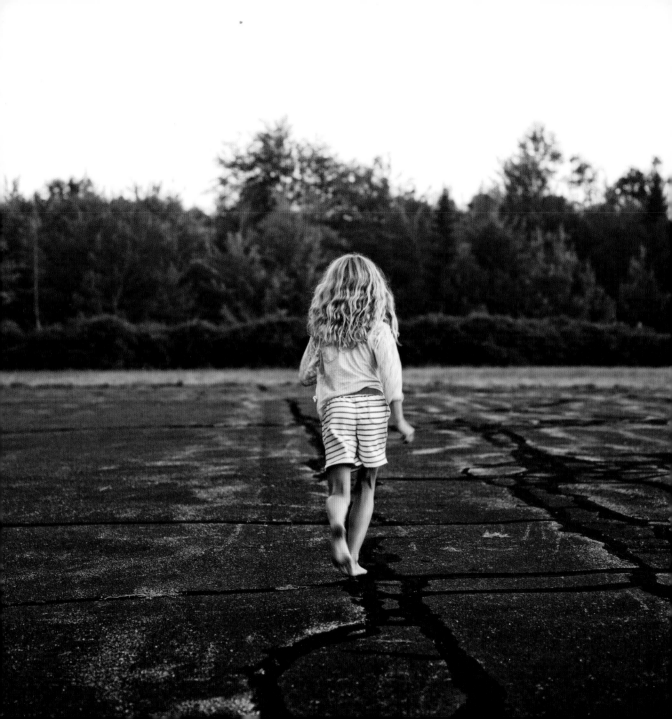

I.

I think the earth from outer space is like this. Some kind of watery, Indigo blue.

Dark lines for rivers. Lighter blue for oceans.

Did you know water tells the story of everything?

Did you know how much there is of it?

And then the green trees painted around the sea.

The trees are harder. The ocean talks to me

and tells me prehistoric things. The trees just whisper *not yet*.

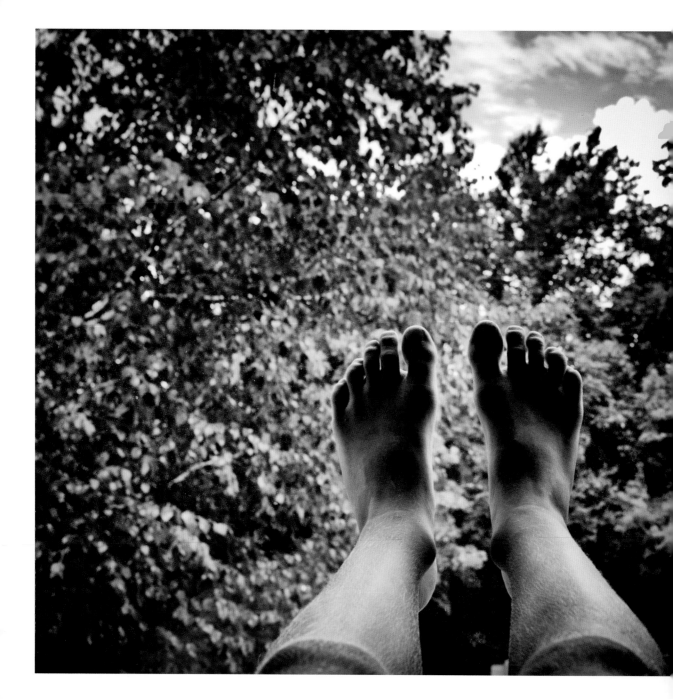

2.

Sometimes the question is how we fit into the picture. Head, shoulders, knees and toes.

If you were here, I'd try to tell you how some days I can float above my body.

It's not quite like flying. And I've never been able to put it into words.

It's as if everything becomes available at once. Everything says yes, this is your life.

Then the leaves sing on the trees. I can hear them. And the clouds and all of my cells—they all say yes.

I'm in my body but outside it at the same time. If I want to, I can touch the sky.

3.

Then sometimes this is June.

And these are the best parts — the wet stones,

the dark roofs

the leaves dripping with rain,

all of my secrets.

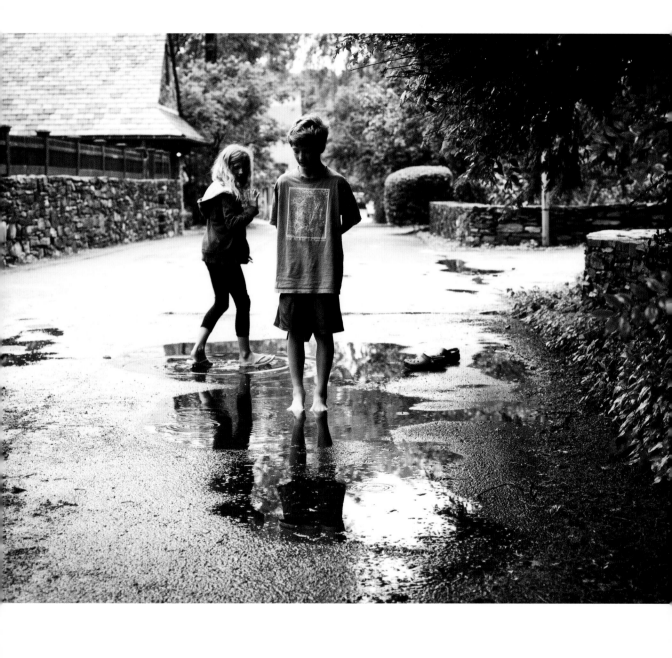

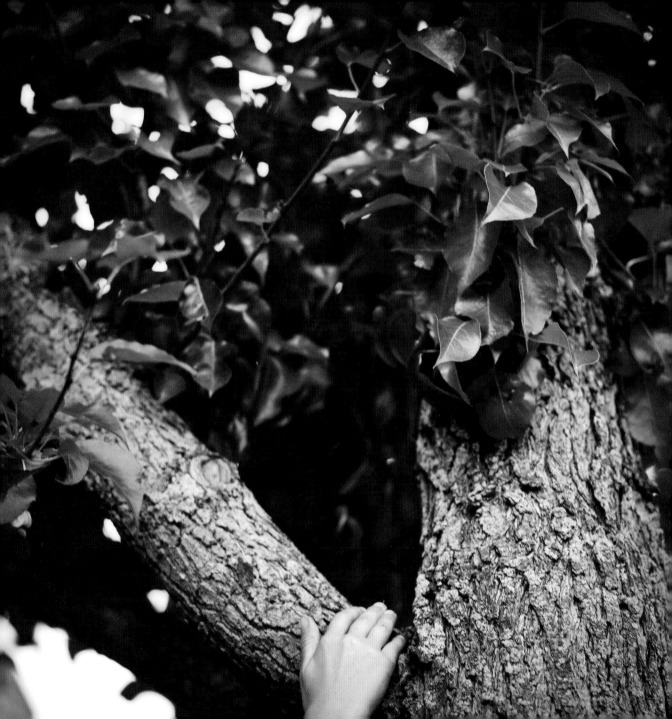

4.

Aidan calls this summer his palindrome life. It means his days unspool
in some technicolor, slo-mo footage where it doesn't matter whether
he starts at the beginning or the end. The sweetness stays the same.
He says words do this too—work backwards in your mind:
noon and radar and kayak. In boyland, where he lives, all the boys
go into the house by the harbor and eat any food they can find.
Then they go out. They swim in the ocean and lie on the rocks
like seals again and again. Noon. Radar. Kayak. Then the boys
climb high in the trees, where the wind is green and tangy.
I'm the mother. I get to ask the boys what they hear when they're up there.

5.

In 1977 I wanted nylons for Christmas and white Dallas Cowboys
cheerleader go-go boots. The nylons Nana got me were aqua blue,
and I wore them to school three days in a row until the runs
down my thighs were like spider webs, and I still didn't want to peel them off.
By then I knew the cheerleader boots weren't coming for me.
They were part of a dream — something about what it meant to be ten
and waiting. But I studied those boots for clues during time-outs
when the camera panned to the cheerleaders. They were knee-high
with side zippers and the perfect chunky heel.

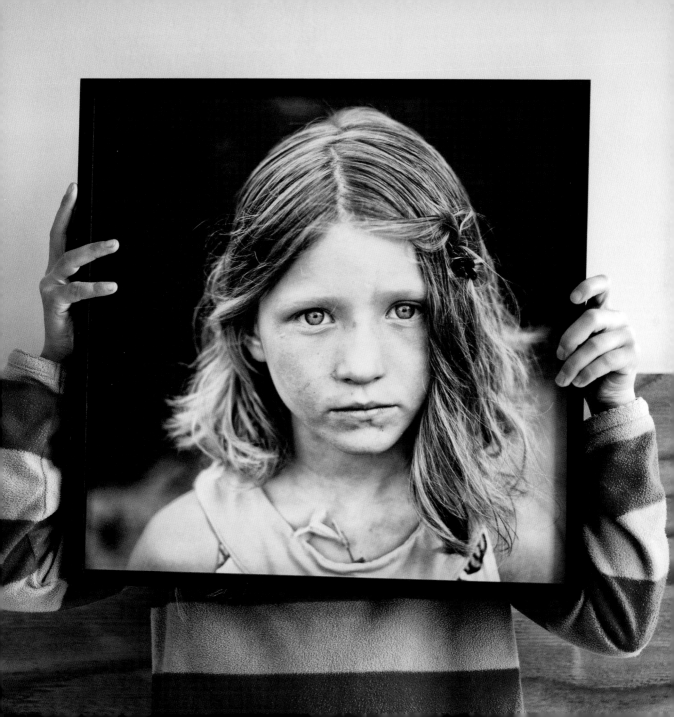

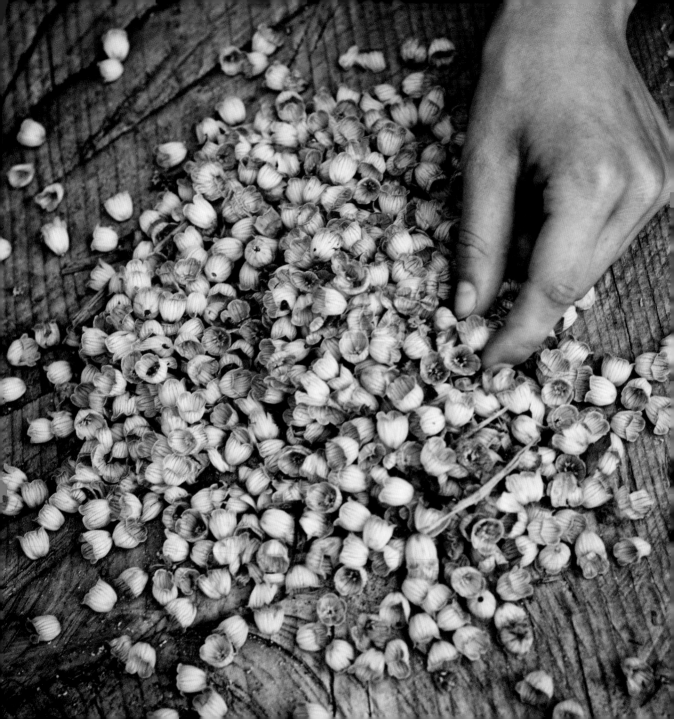

6.

Right before the boy fell asleep, he asked his mother what he should dream about.

He was on his stomach with his little face towards the wall, leaving her already.

His dreams called to him, and the pale flowers rang like chimes.

Oceans, the mother said. And rivers. And trees.

This is how much I love you, she said.

More than these three things.

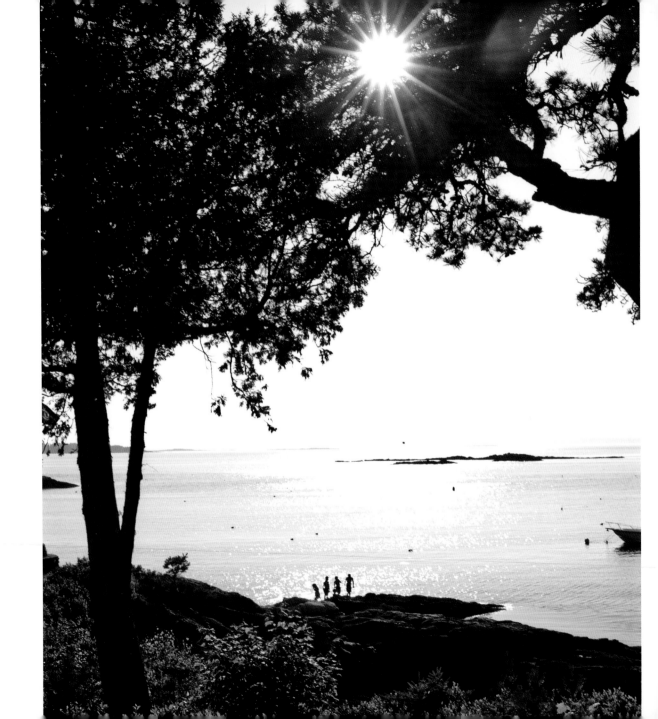

7.

You have to be sad, the boy said to his mother, to understand happiness.

He was eight and summer spooled out in front of him,

the most thrilling thing maybe ever. Something delicious

you could eat. The mother nodded like she understood him.

But what she was really thinking was how to protect him,

just a little longer. And how the sky

seemed so forgiving in July. After he swam,

the boy's dark hair was wet and furred like a seal.

8.

When I jump in, I can see my feet down below me,

whiter and skinnier than real life.

My brother asks me to count

how many seconds he can hold his breath underwater,

and it doesn't feel exactly

dangerous, but like I'm in a movie

treading water and counting,

and looking at my feet when I dare to.

When will all the parts of me reconnect?

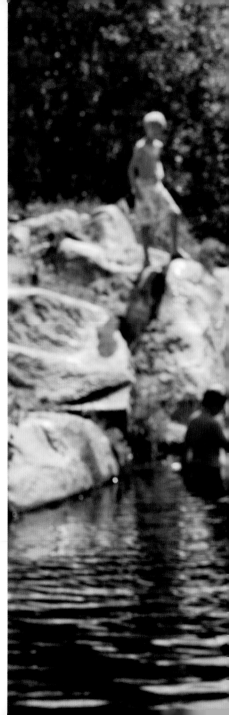

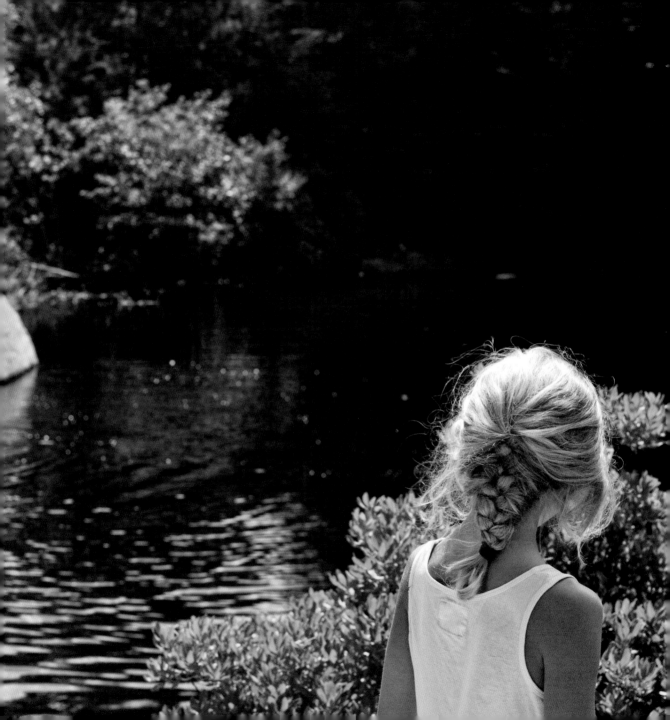

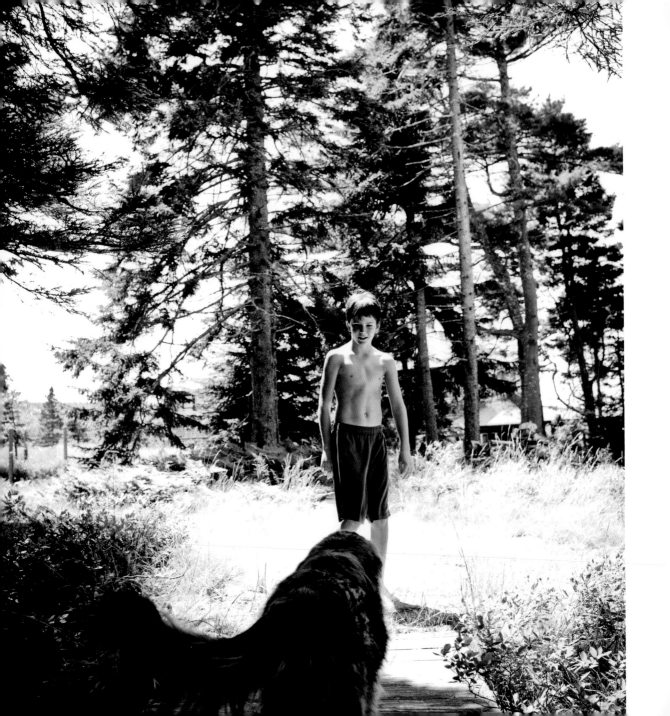

9.

I speak other languages on the island. English yes.

Chinese, a little. And dog. Bear and I take the boardwalk

to the cove, and he's really old now so I don't think he can hear me,

but I whisper to him anyway, and I swear he understands.

He's gentle like that. We swim, and the wind makes that high whistling

sound in the trees — saying summer, summer, summer, this is the summer of your life.

IO.

We slept in canvas tents on wooden platforms at night,

and I could reach my hands up and poke the sides

where the rain pooled. I liked that tent.

I liked how the night sounds were all around me,

and we were almost living in the woods.

What would that be like really?

If we had to survive on our own?

Liza and Kimmy and I all passed the swim test

so we could jump off the high diving board, and this helped.

I missed my Mom so much that I knew it was better

just to swim and not talk about the missing.

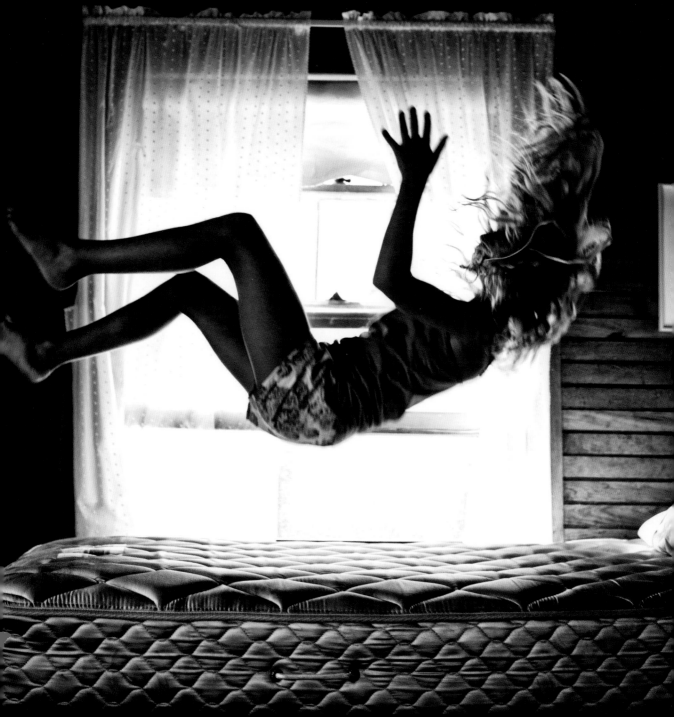

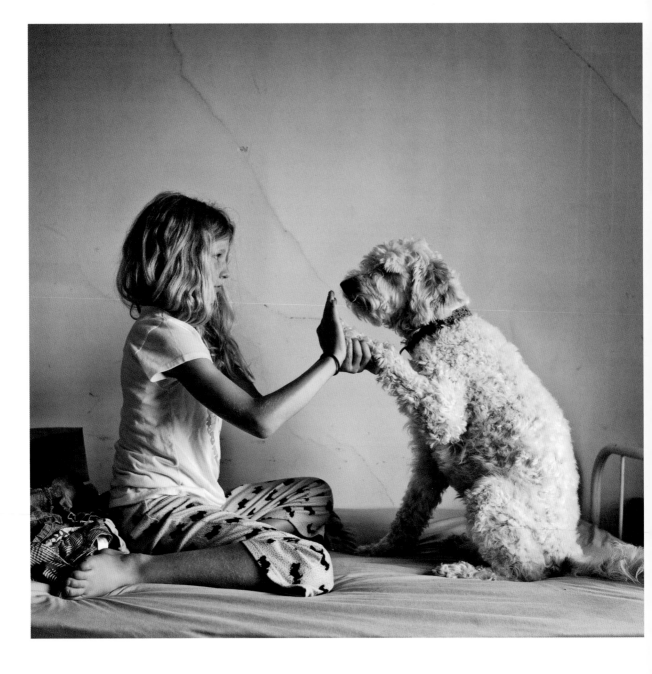

II.

I, Liddy Millspaugh, solemnly swear to love you and honor you 'til death do us part.

(But that doesn't mean I won't run loose on the island and hunt seagulls).

And I, Lolie Millspaugh, solemnly swear to cuddle you and bathe you

(even though I hate the baths when you smell like dead seal).

Sister I never had. Keeper of the family truth. My witness.

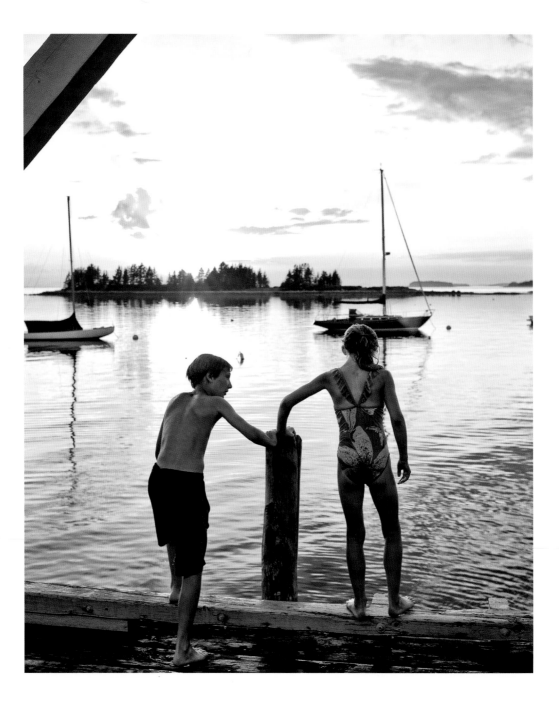

12.

You gonna go? Cuz if you're not then I am.

On the count of three. Pull everything in real tight, your arms and legs and toes.

It should feel like your whole body's holding its breath.

Then it doesn't hurt.

Ready? Together.

13.

This is just to say

I have eaten the black raspberries that were in the field

so tart and so sweet

and which you were probably hoping were for dessert.

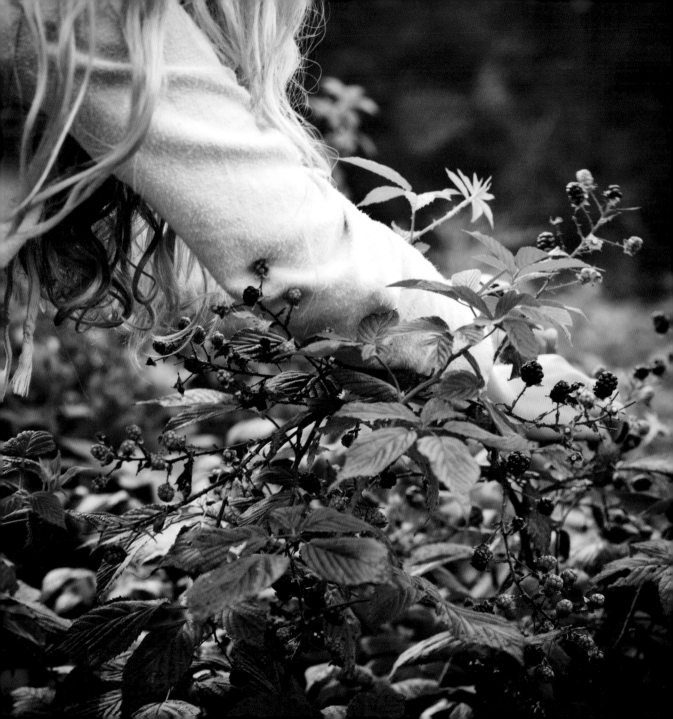

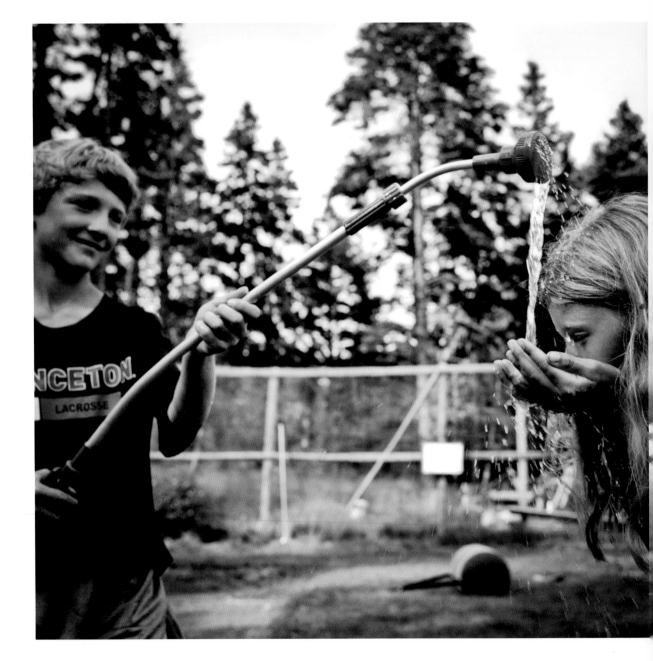

14.

Yesterday after you locked me out of your room

I spent the whole time with my face pressed to the gap

between your door and the floor watching you and Izzy dance.

The song was Brave and you did that routine with roundoffs in the middle.

You should have let me in. For one, I'm brave.

Two, I'm good at round offs. And three, I can dance.

15.

Today the ocean is blue like a galaxy in outer space

where you swim through stars and black holes

and the forcefields of moons, and it never ends.

If I think too much about infinity, I have to close my eyes.

Down here the earth is chained like a little dock to the rocks.

We spin and spin and we don't ever let go.

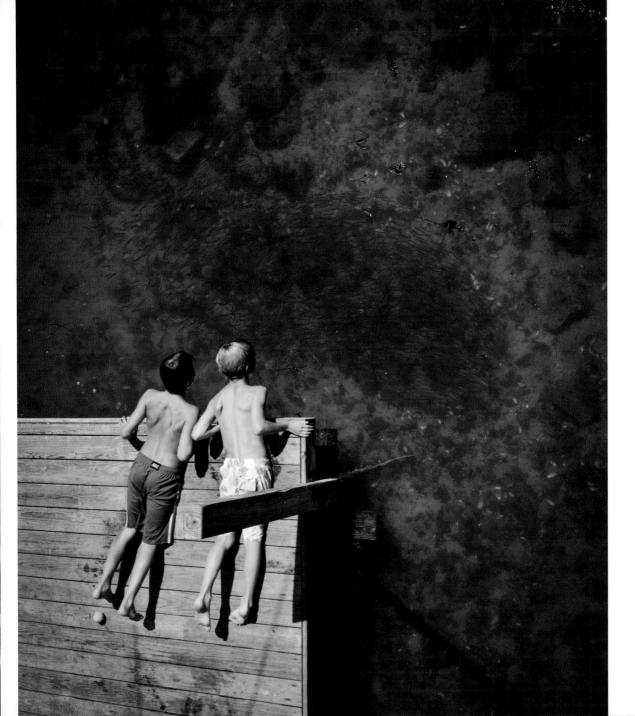

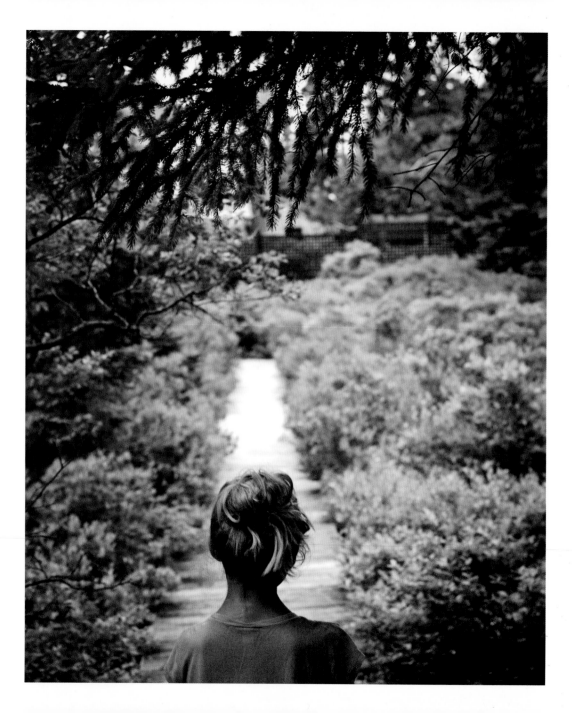

16.

Mostly we ran up and down the boardwalk to see the mail boat come in.

We didn't have a radio, so we sang pop songs out loud together on the porch,

my brothers and cousins and me. The trees on the island had long, wild hair like me.

This is what I remember. My mother. Always my mother. And how my brother chased me

in the dark on the dirt road but stopped when I got scared.

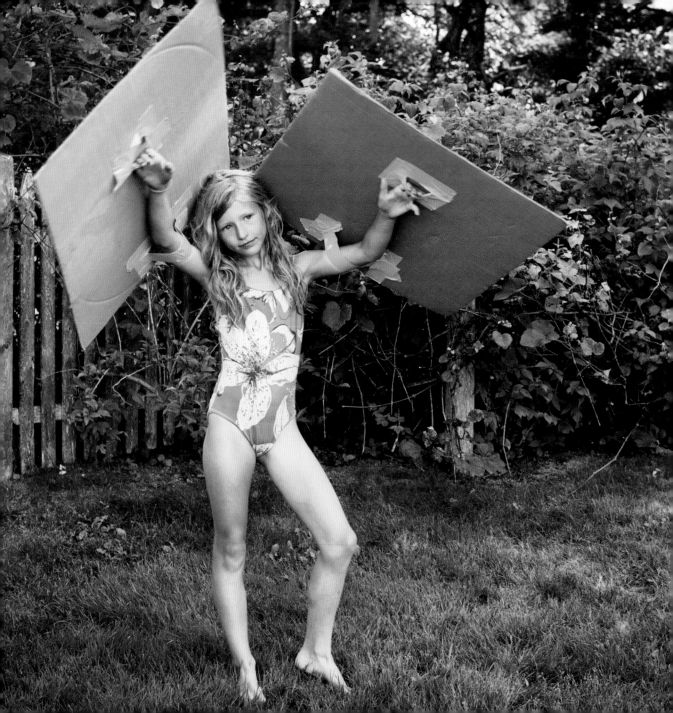

17.

Flying. Yeah. It's something I do whenever I can.

I fly in the morning when the sun rises.

I fly at night when there's no moon.

I fly with my eyes opened or closed.

It's the very greatest thing.

Sometimes I wear my new back-to-school outfit when I'm flying.

Sometimes I just put my wings on and practice lift off.

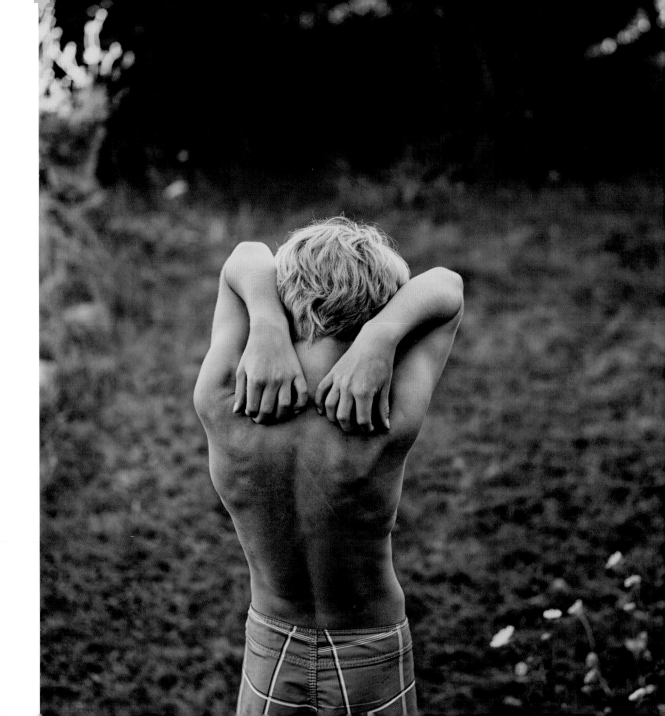

18.

By the end of the summer my mother calls me something more animal than boy.

And imagine if you could talk to wolves.

I mean really talk to them.

Would you give up being human?

And what if they taught you their wolf language?

Would you walk away from your mother and your father,

to live with them? Would you never come back? And once you chose,

would you be gone to the people you love forever?

19.

In fourth grade we built a terrarium in our old fish tank.

It was like my jewelry box but without the ballerina on the little pink stage

who twirled whenever I opened the lid. Instead there was a tiny forest

of green mosses and I wanted to live in that terrarium, but be the ballerina too.

I wanted the inside world and the outside.

I thought all I had to do was choose.

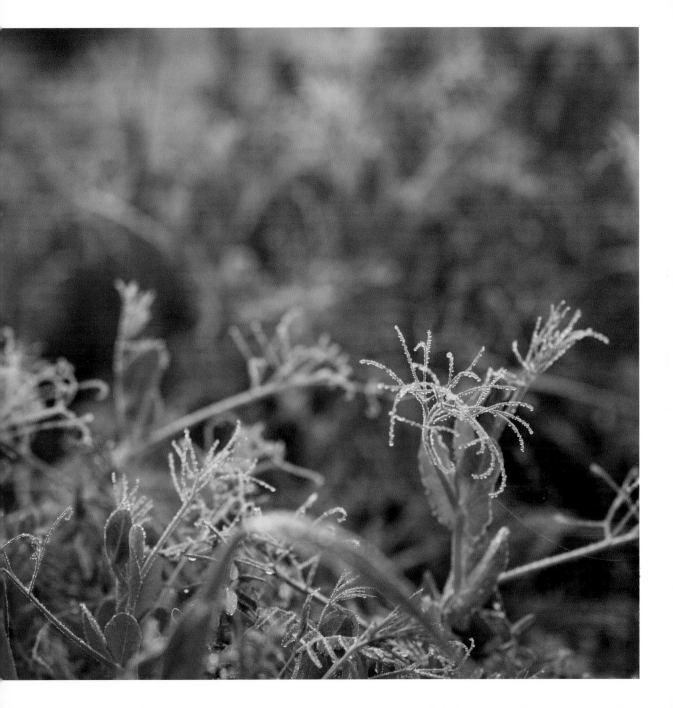

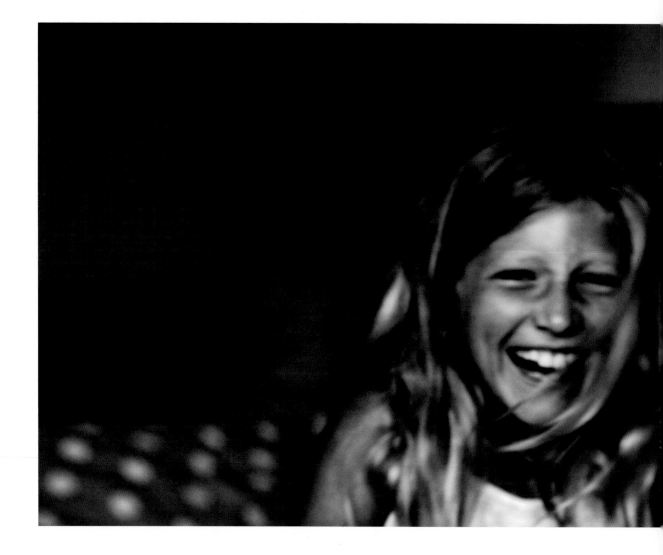

20.

The whole beach is made of slate — the really good kind for skipping.

And you can write your name on one rock with the other.

It's like saying I WAS HERE. Until it rains. Then the fish come out.

They're called perch, and they live under the dock with the eels.

You make me laugh when you put the worm on the hook.

You always do that, make me laugh.

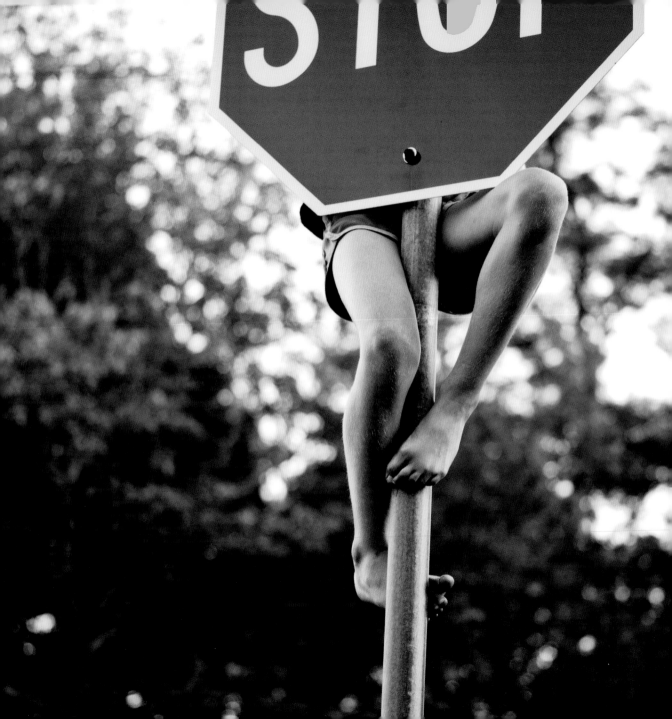

21.

There's a graveyard down behind the house that isn't really scary —

a green field with lots of old stones.

Hedgehogs live there and possum.

The skunks come at night and sometimes we get crows in the trees.

One crow says to the other, Stop Here. This Is The Place.

My street. My house. My mother, father, brother, brother.

I still have to look down at my legs sometimes

to make sure it's really me, and when I forget

who I am completely my mother reminds me.

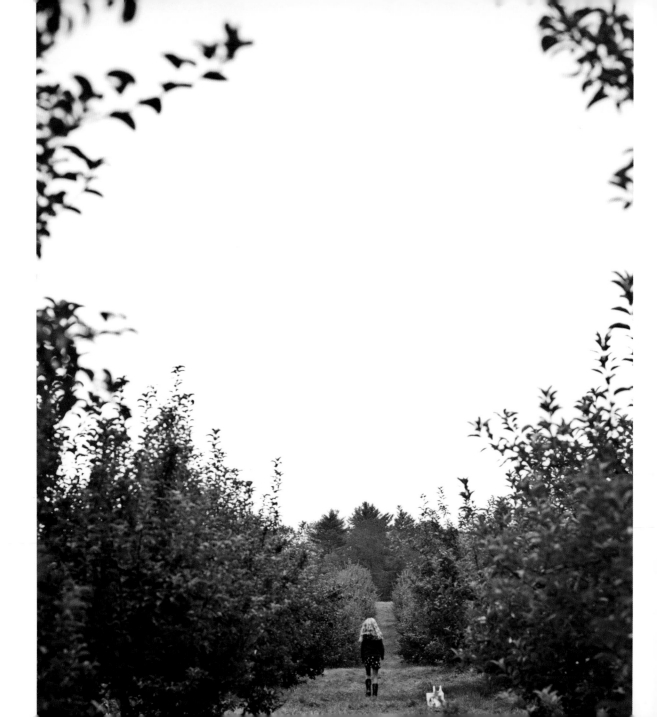

22.

I didn't live near the orchard but my grandfather did,

and the trees were like rows and rows of old people

all with different personalities. The smell of apple

was everywhere. The mushy ones

on the ground smelled sweetest.

Walking in the orchard felt a little bit like flying,

a little bit amazing and a little like being lost. The good kind of lost.

23.

I called your name last night just before I fell asleep.

I wanted to see if you were going to bed like me.

We need one of those long strings between our houses

with a coffee can on either end that we can yell into

so I always know you're there. Good Night Isabelle!

Is what I'd yell. Can you hear me? Good Night! Good Night!

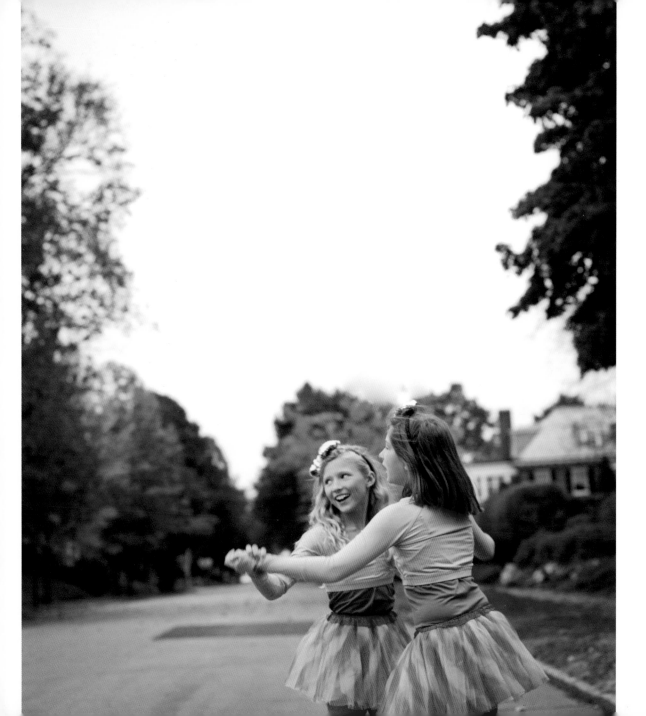

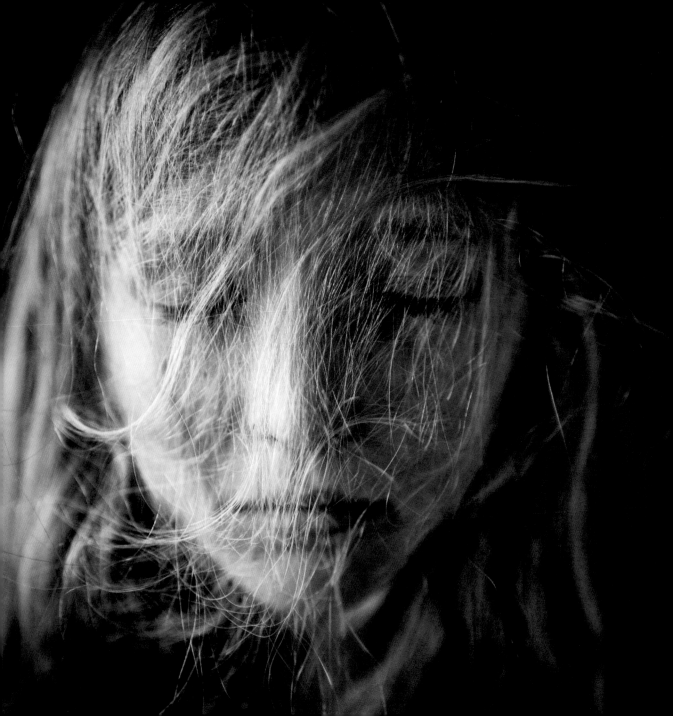

24.

In school I learned the word chrysalis. It means outer shell,

the place where the butterfly turns into an adult. The hard casing.

My shell is soft like silk after I shuck corn.

Gossamer. My teacher said when the butterfly hatches,

its wings are like this word, gossamer. So delicate you can't touch them or they'll break.

25.

Sometimes my bedroom feels like that Jaques Cousteau movie I saw in 5th grade

where everything was underwater and you knew the blue sky was up there somewhere

but it was always out of reach. I'm older now. Maybe my heart is like that —

a place you can't ever go, but a room I still want you to enter

where the doorknob is like a piece of my mother's costume jewelry.

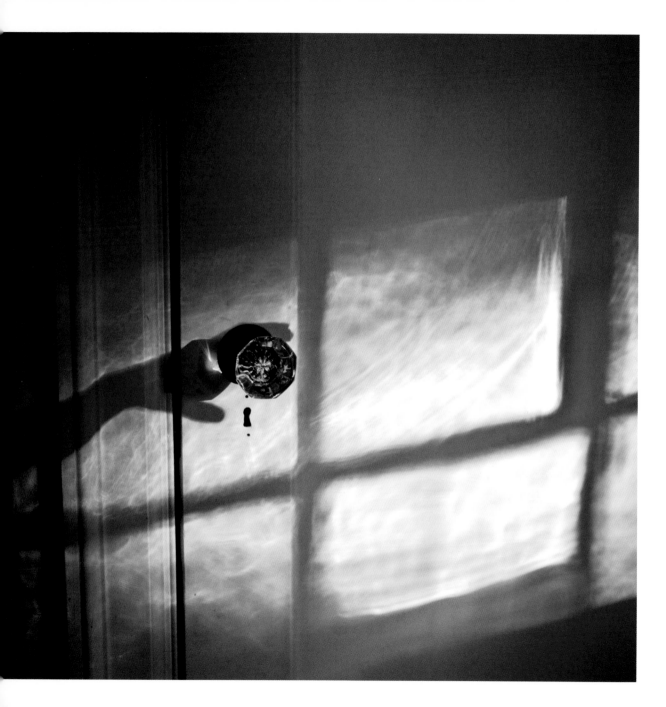

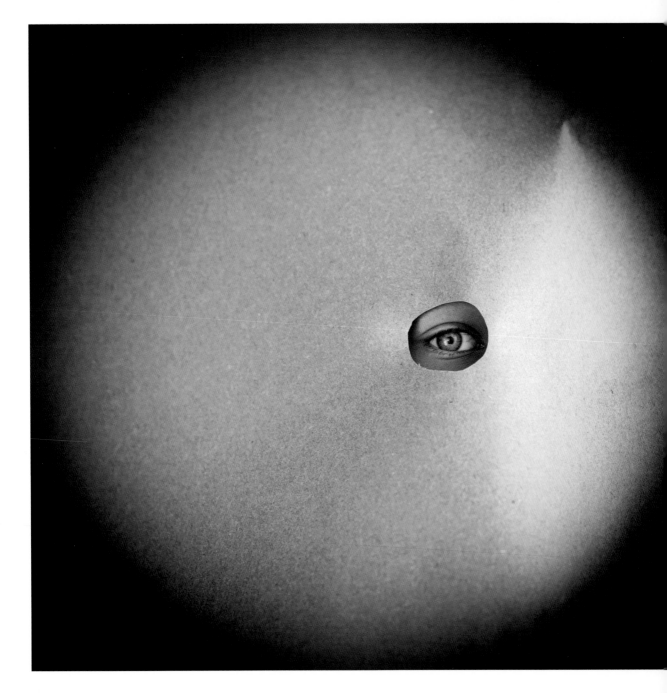

26.

It got so I didn't want to go to the circus. At first it was just the clowns

who scared me. I told my Mom how I thought they might kidnap me.

I was six. I was always talking about kidnapping

because who does that? Something so mean?

The rest was okay. The Arabian horses were better than okay.

But then the elephants came out, and I knew we could never come back.

There were three of them. Their trainer wore a green sparkly dress

and cracked a whip by their feet. Then they climbed up

on three red stools and looked so ashamed.

Their eyes were like doe eyes.

Like the eyes of kind old men, but much bigger,

and they all said save me.

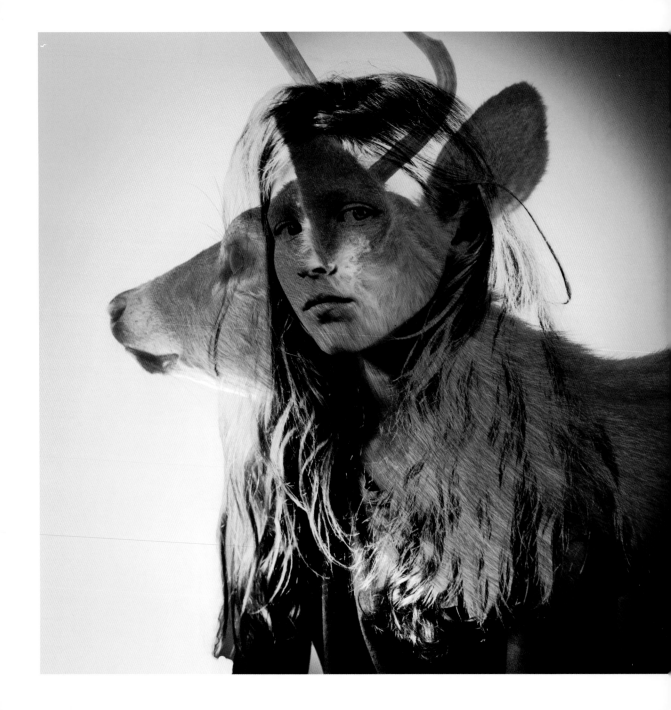

27.

Some nights I got to lie in her bed and watch my mother

choose a dress from her closet, then brush her long hair.

She hardly ever wore perfume except those nights

when her friends came over. I knew her body

as if it was my own. And it made me feel so good

to know where I came from.

28.

Things crawled out of the fire. Ghosts. Baby crows

wanting food. My mother said something about Shakespeare and three witches.

That whole summer the fire was bigger than me until my father tamed it.

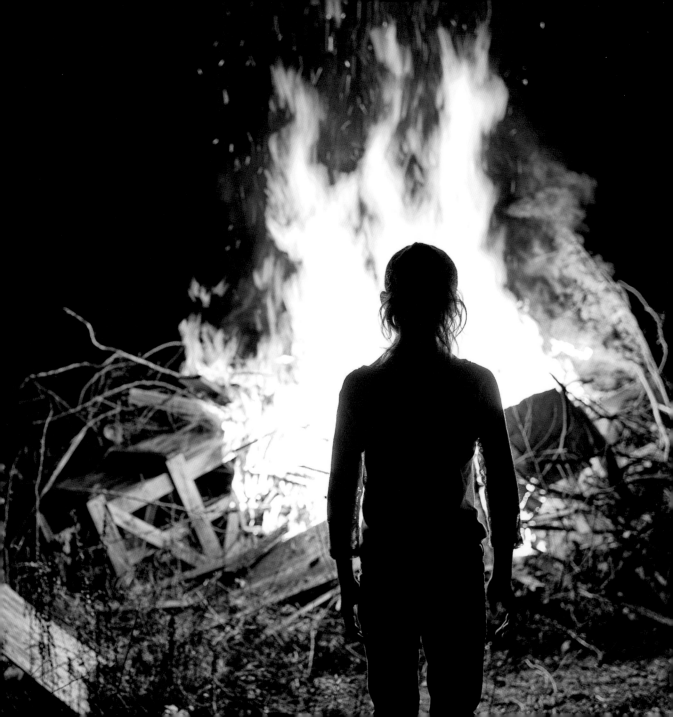

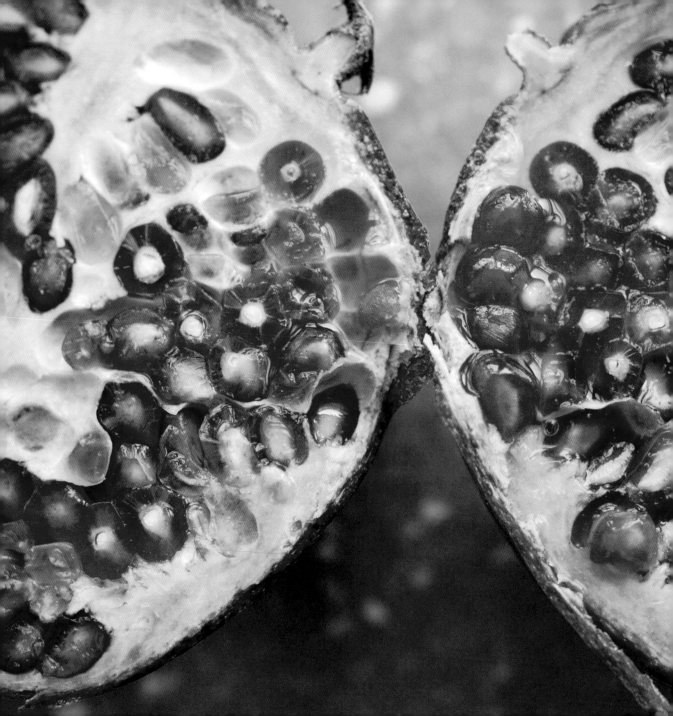

29.

One-third of every year. That's how long Persephone had to live

in Hades for eating the pomegranate. She was just a girl.

They called it winter while she was down there,

and her mother refused to let anything grow up here on earth.

It stayed with me all of sixth grade—how good the seeds looked.

Like candy. And what would that feel like?

To leave my mother again and again?

To know I had to go back to the underworld?

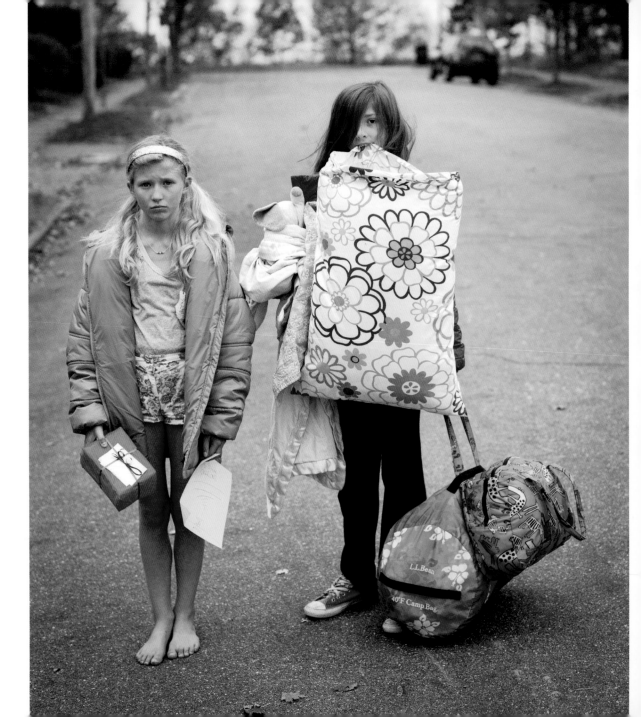

30.

Liza lived in a farmhouse with a barn attached to the kitchen,
and when we ran away we were going to crawl through the trapdoor
in the barn floor. We kept rolled sleeping bags in Liza's closet,
waiting for the sign that our lives as we knew them were over.
We practiced opening the trapdoor and dropping to the ground
underneath the barn. It was wet down there. And don't ask me
exactly when life got more interesting. Things picked up.
Then it didn't feel like we were missing something anymore.

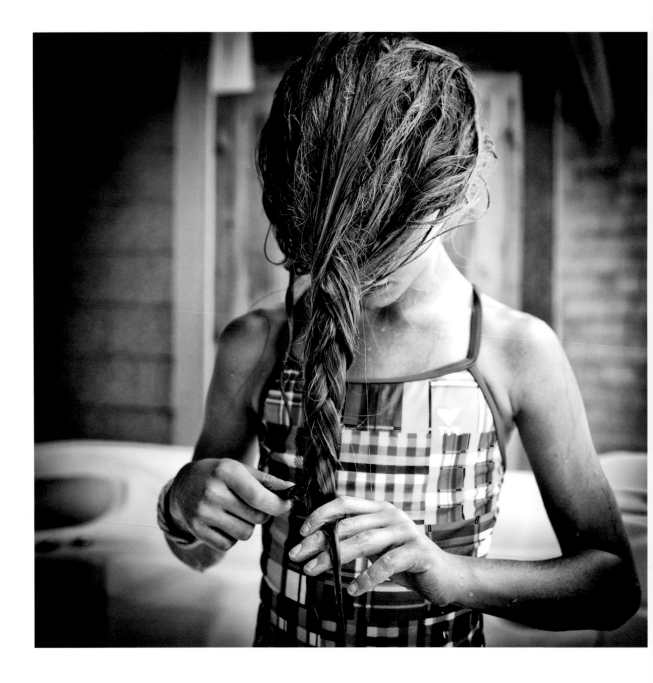

31.

I think smell is the sense that people miss most when they lose it.

Not eyesight. Not hearing. Not touch.

I'd miss my hair most. It talks to me. It tells me my history.

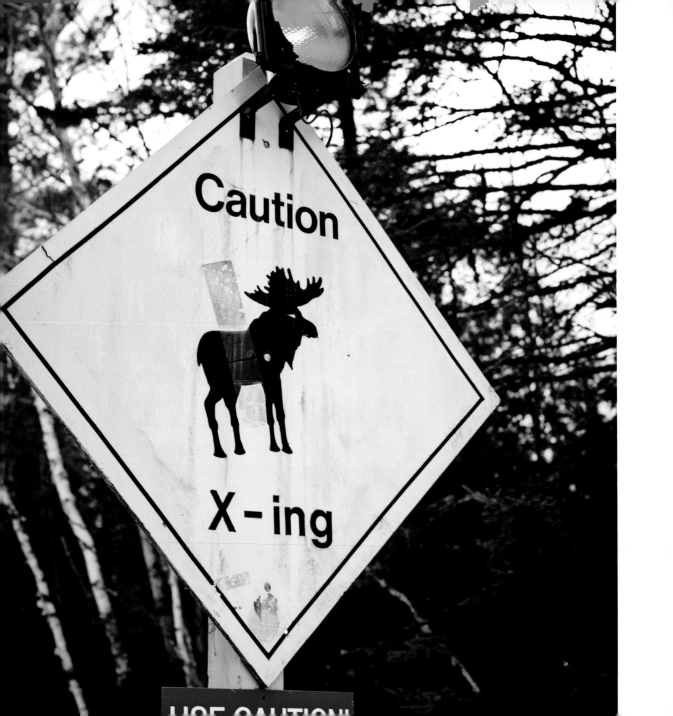

32.

When I was a very little girl I carried the idea of a moose in my head.
Maybe you did that too? Imagined something so much bigger than you,
something pure and wild that tipped the universe back into balance.
Because there has to be the wild. And the green thicket of unknown
and the moose with its impossibly shaped nose and beat up hooves.
There was a place north of Portland, where the pine trees gave way to dark
ocean, and this is where I knew the moose lived—in the brackish bogs and burrs
and wet moss. I walked out into the muck of the low cover and waited
for the moose. Wanting to see it. Not wanting to see it, because what if the real
moose was nothing like the moose I held in my mind? I wanted both. I wanted
to never grow up.

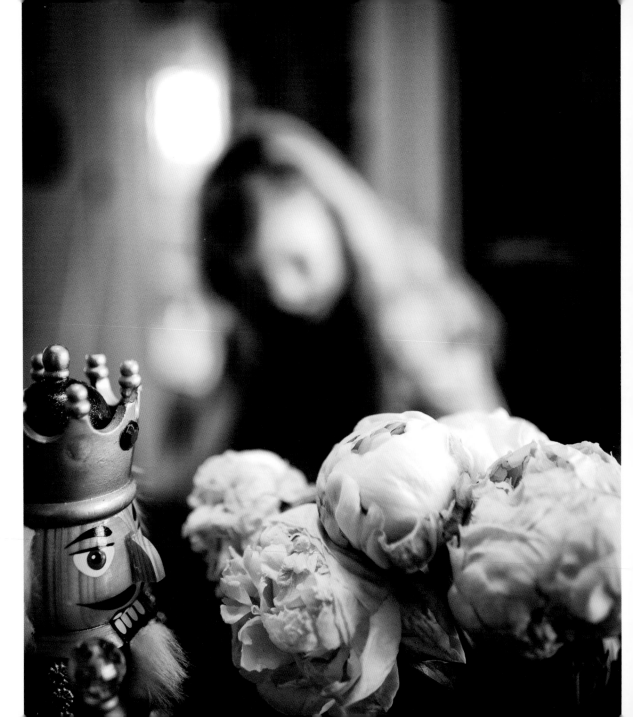

33.

On her 13th birthday the Flower Princess said to the King,

Please take me out of the castle and into the city.

I want to see the people and the flowers there.

And her father couldn't hide his frown. She'd reminded him

of when she was very young and he could still protect her.

34.

I remember the long curve of road along the Kennebec River, where the tar

turns into dirt and you're lost in the primordial forest of your mind.

I remember how we'd park at the farm—it was a simple place,

and ride the horses up past the quarry. I felt the surprise of the trees every time—

that they were still there waiting for me, and how could I ever have doubted them?

Then I'd leave my body and become a tree for an instant. I had faith in the frozen hay,

and in the ruts in the field. Faith in the silvered pine needles. The air up there was thick

with that kind of belief.

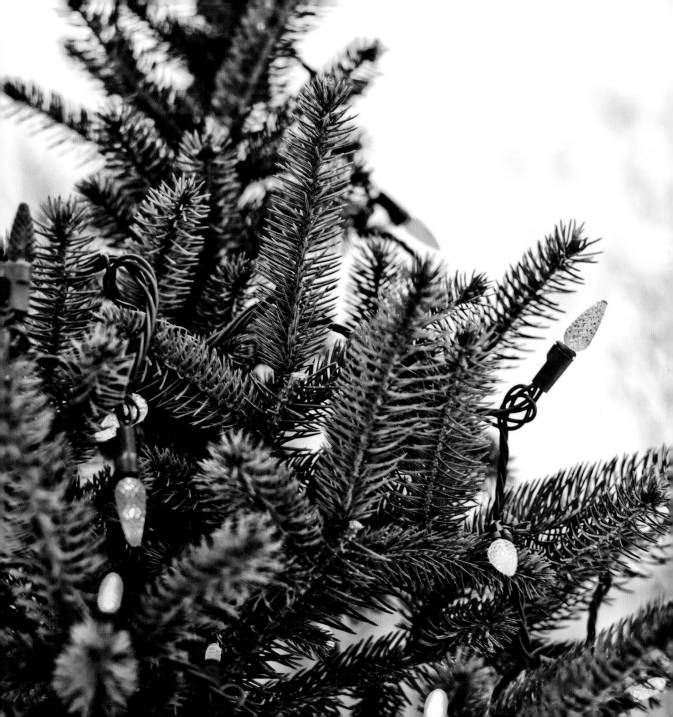

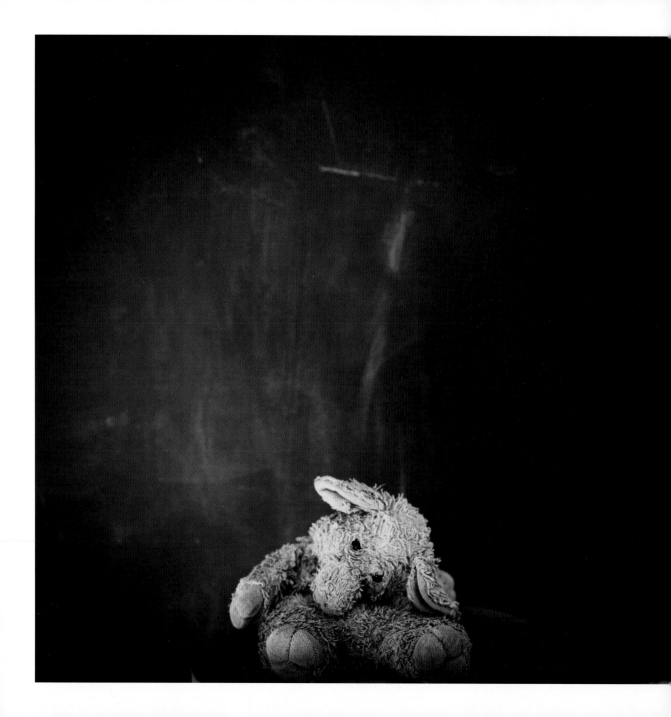

35.

I know all about imaginary friends. But Piggy is different.

You see I am Piggy and Piggy is me. I'm not sure how to spell

doppelganger, but my brother said it means double.

So this is Piggy. My good shadow.

My eyes and nose and lips.

My heartbeat.

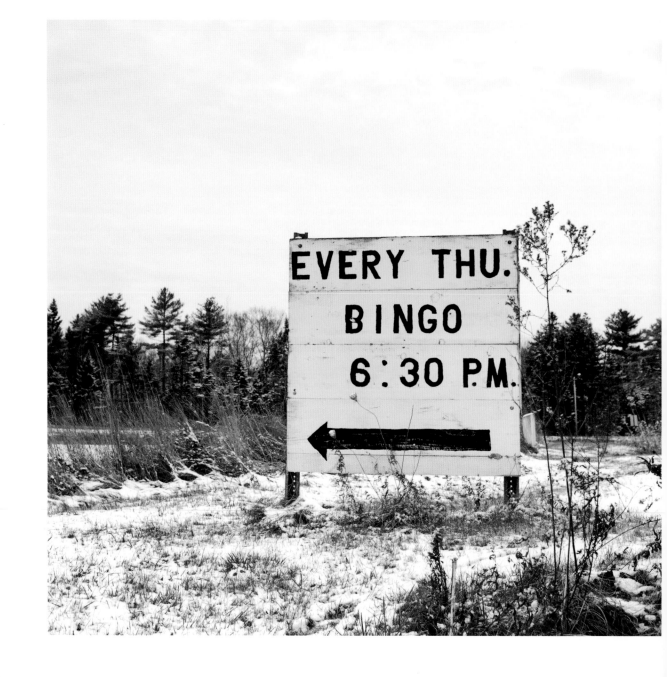

36.

The fields have tufts of green hair

and the sky is so big and flat

that everything feels entirely possible.

Everything feels within reach.

Which is why you should come with me.

37.

What about the part where there's just me and no you?

I know it's late. I know I should be asleep.

But can we talk about that for a minute?

Because this is the part I don't ever understand.

And yeah we've gone over it before.

But tonight it feels like a blizzard in my head.

I'm walking for miles and miles through the snow looking for you.

Always looking for you. Where are you? Where are you? I can't see you.

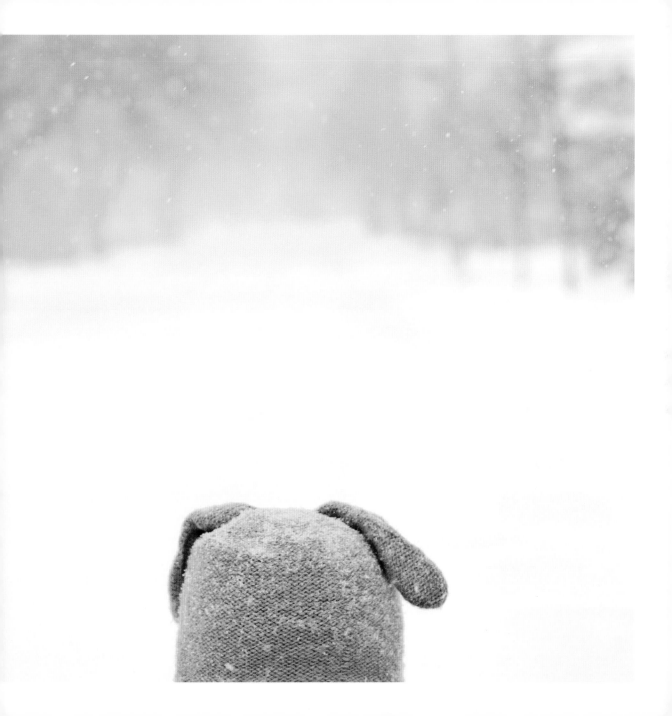

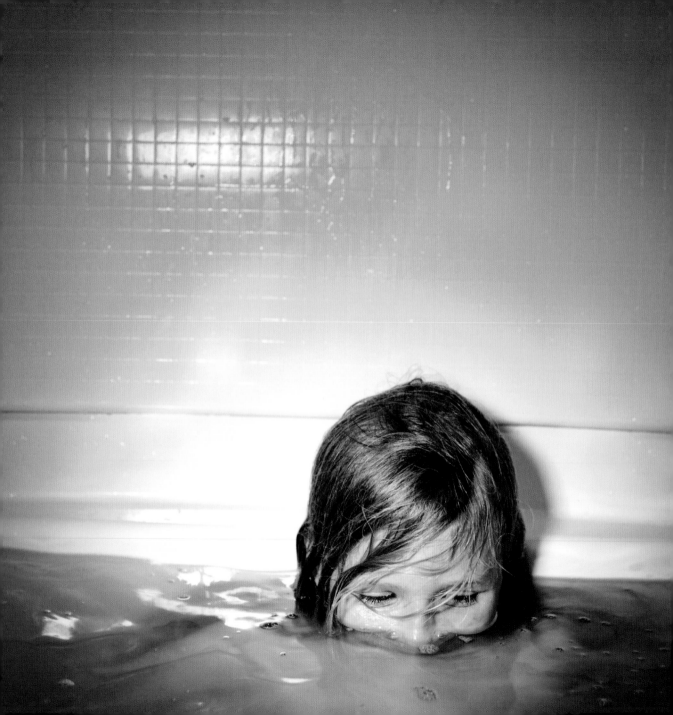

38.

The movie I play inside my head is always in color,

and the soundtrack is me

humming underwater.

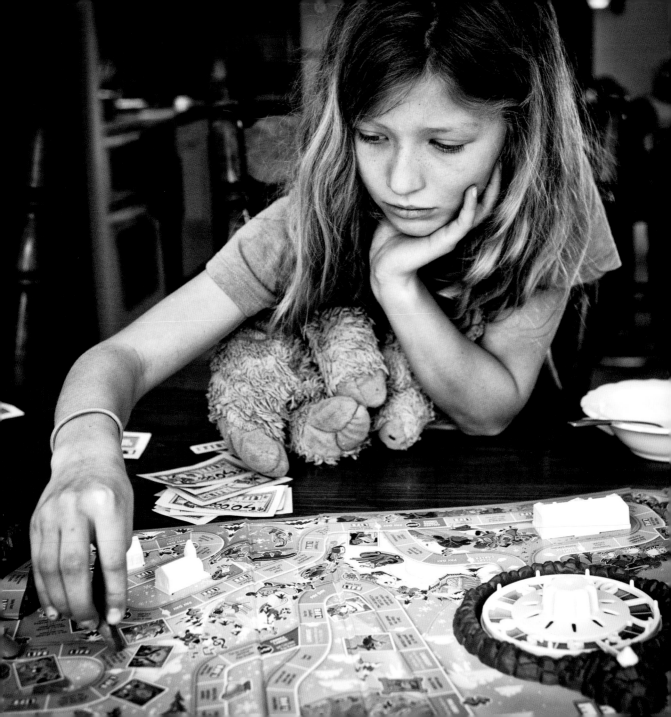

39.

On the weekends we get sugared cereal and morning t.v.

but sometimes even that's not enough to stop me.

Today I told my mom that I wanted a new mother,

someone who wasn't so, you know, involved in my life.

Wasn't like watching everything I did. Someone like the other mothers.

Yeah, I told her, *a new mother. That's what I want.* Then I spun the wheel.

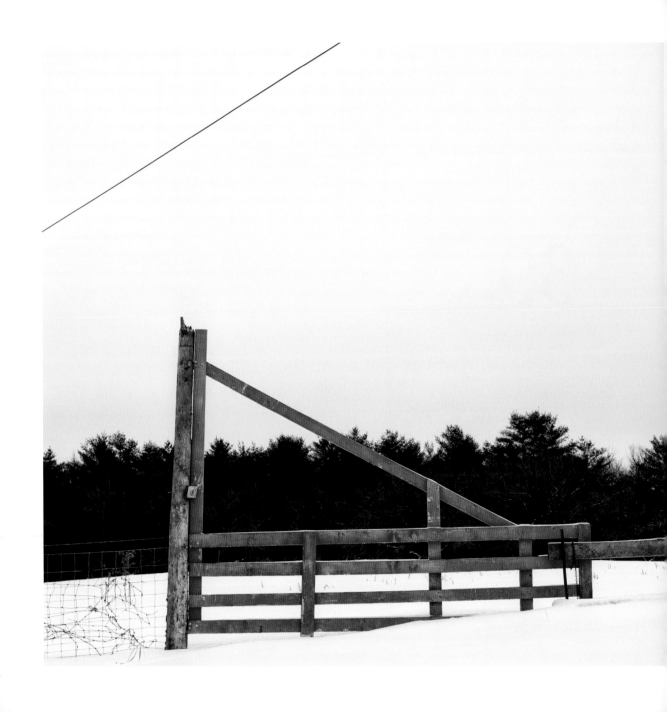

40.

I could tell you how to find me

in that dark stand of trees, but

I would still be keeping you out.

41.

Mrs. Paine kept the little slips of paper on her desk

for when you needed to be excused early.

We'd fold them into squares and ping them at each other.

I could barely read Liza's handwriting. Or Neil's.

Or my own. First there was science class,

then social studies, then math.

Do you like me? Circle Yes or No.

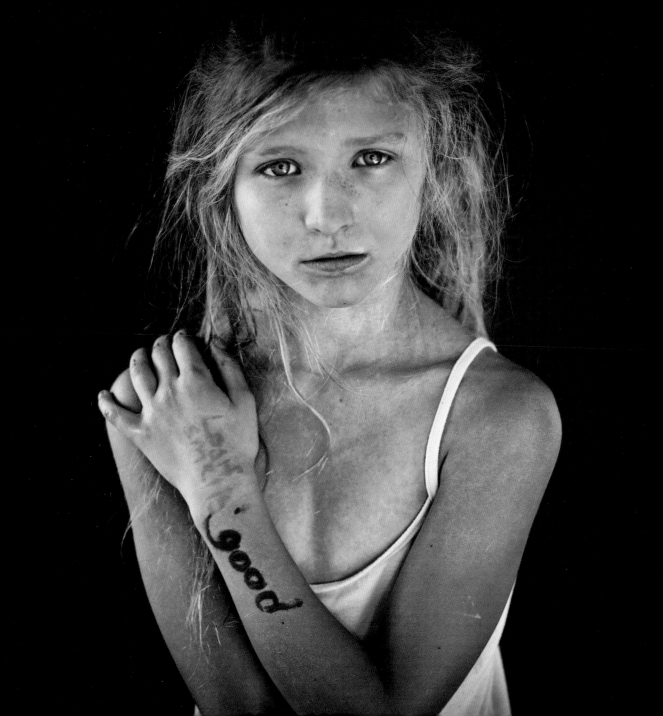

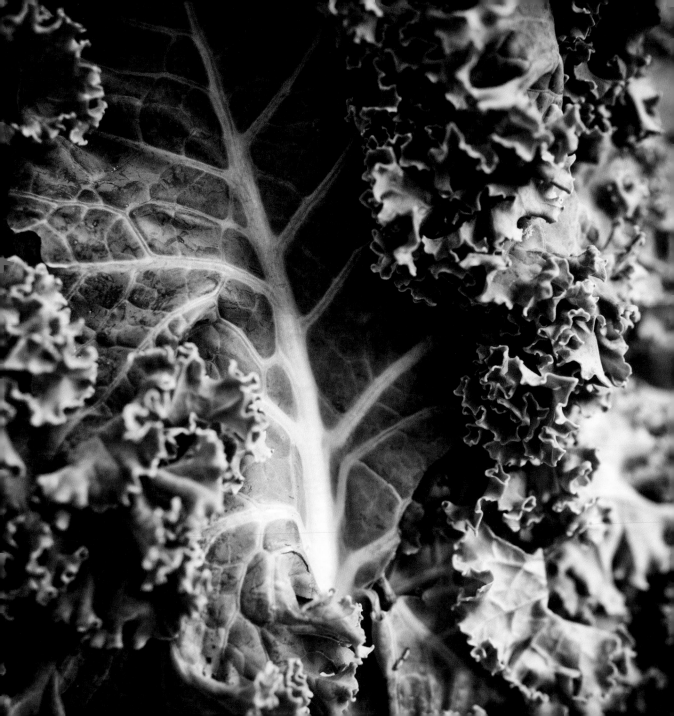

42.

The forest was green and lush like Narnia and the rivers had women's names: Amazon and Nile and Mississippi — I think she would have been the one with long hair. Small animals walked on the paths, and there was never any bad news. Just plots of land where people planted rice.

43.

I think it's how you hold your neck. It must be very straight.

Then your neck and back are part of the same flower stem

like there's an invisible thread pulling up on your head.

The ballerinas speak a language that's as complicated to me

as the Latin verbs my brother writes on the kitchen wall.

First position. Second position. Third and fourth. Eyes forward. Chin up.

44.

The owl flew into the field so early one morning

that the girl was still dreaming. And the bird said to her

this is the beginning of your new life. The girl nodded her head

as if she understood and promised herself that everything now would be different.

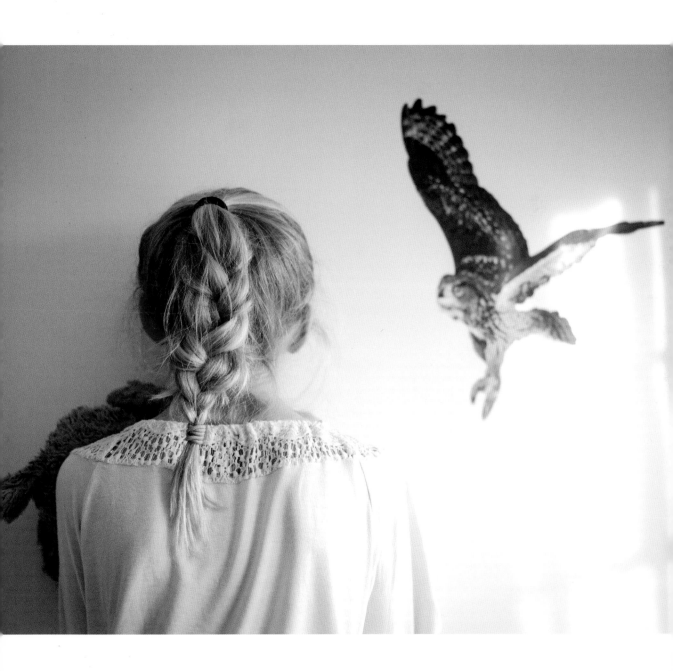

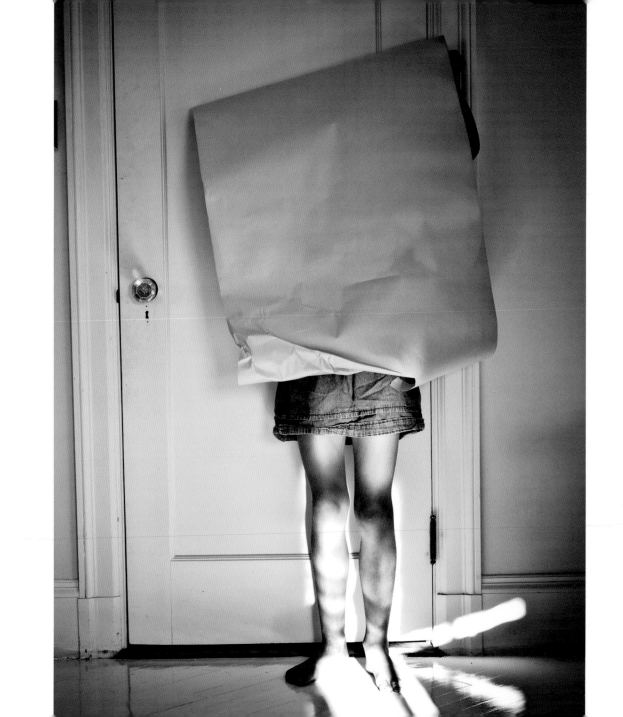

45.

In second grade Mrs. Norton played the guitar

if we finished our lesson in the Rainbow Workbook.

I liked the clicking sound of the locks on her guitar case

almost as much as the sound of the chalk.

Mrs. Norton was already one of the good ones,

but then she'd sit on the round table near her desk and sing,

and I loved her with all my heart. No one else ever sang like that.

Our little school was in the woods, but when she played,

I thought we were at the center of the universe.

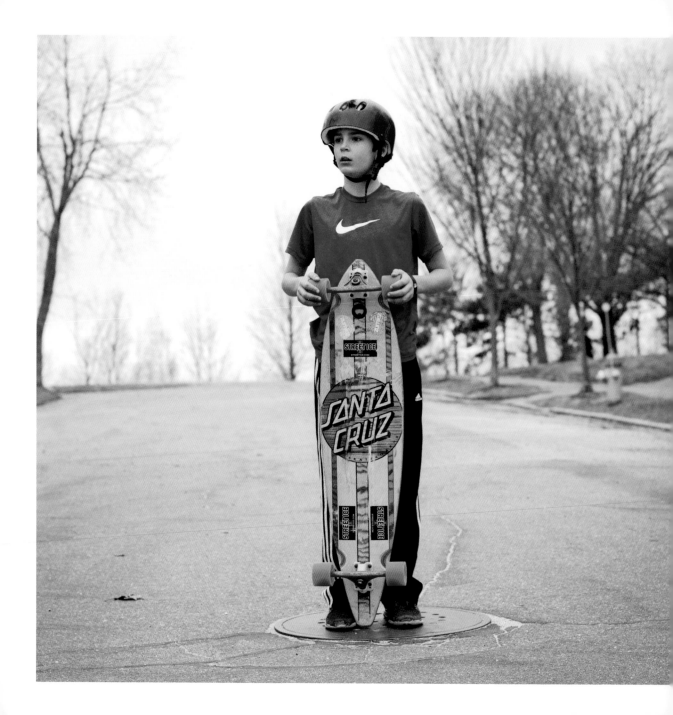

46.

We live near the river with the tug boats and the drawbridge

and the oil tankers. It's a small city. I'm eleven.

My age is all I have. Plus your word. So don't lie to me.

I can always tell when you're lying. At night I have to keep

the covers over at least half my body, even when it gets hot outside

and I'm sweating. This is how I become invisible.

This is how I know I'm safe.

47.

Music does this too — folds itself inside

my mind. I think it's green in there.

And full of surprise.

The notes are perfectly shaped.

They say come a little closer.

Come. There's something I want to tell you.

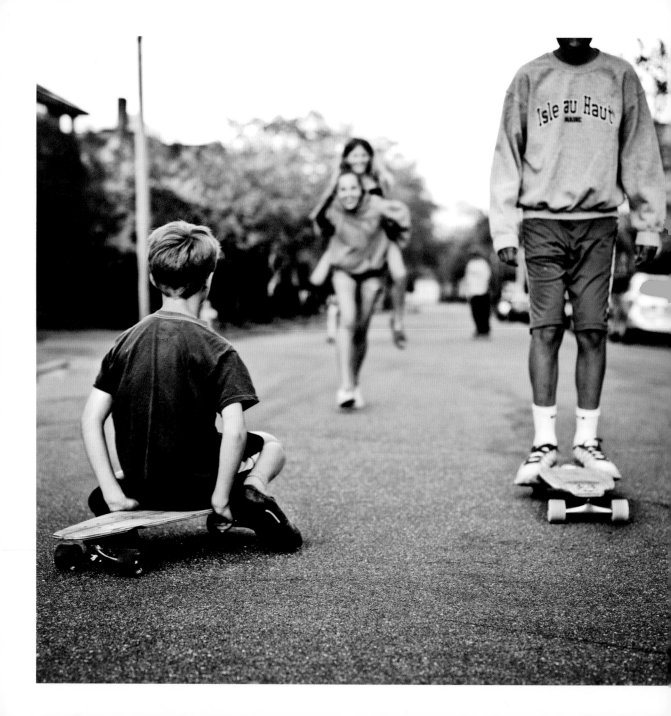

48.

After dinner the boys come outside with their skateboards.

Charlotte sometimes comes too and we play hopscotch.

Last year she gave me all her American Girl dolls.

I couldn't believe it. This is what I know: that I'm ten years old,

I'm American, and I'm a girl. The rest is confusing.

I like it when Charlotte and I talk because she's older.

She's already been through ten. She's made it to thirteen.

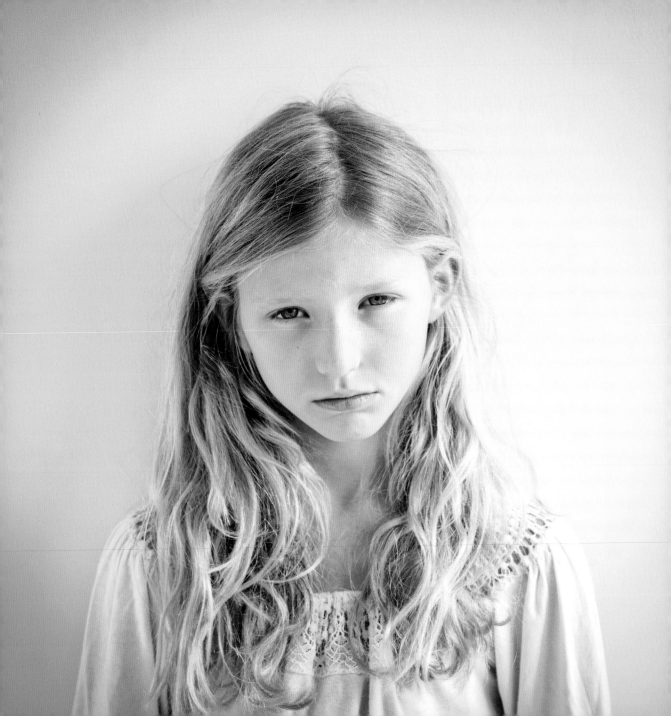

49.

This is the part after the beach when the sun still feels like it's burning my brain.

It was such a good day but now I say things I don't mean and need you

to figure it out for me. I want you to come closer when you're standing right there.

Come closer please. But all I say is go away. When I was little, you told me

I found you in the yard and put my arms around your leg and asked

"Where are you Mama? Where are you?" And you said, "I'm right here."

You'd think I'd stop testing. You'd think I'd believe you by now.

50.

We could live here under this tree.

You have to push off five times in a row

with your bare feet. Little pushes

to get you going. Then you spin.

The idea is to get as dizzy

as you can without throwing up.

Same with the Cumberland Fair.

I want to go on all the rides

but then I have to lie down in the grass near the horse track.

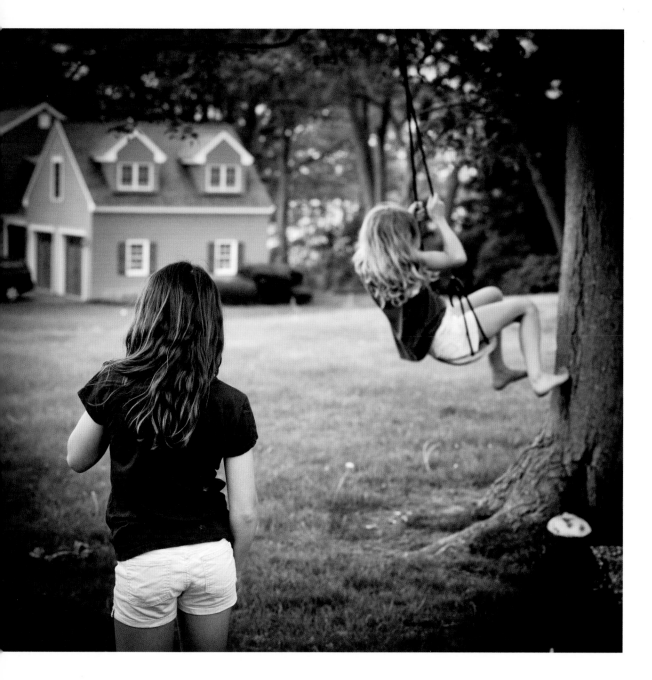

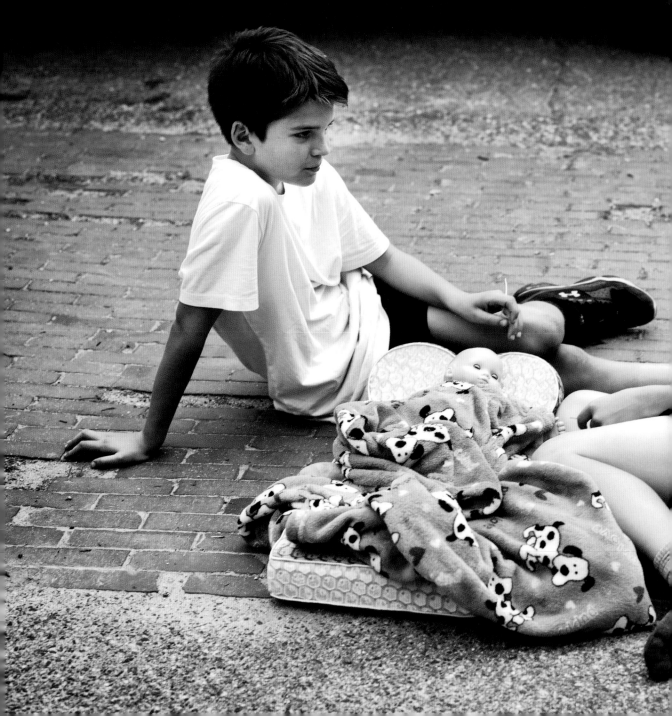

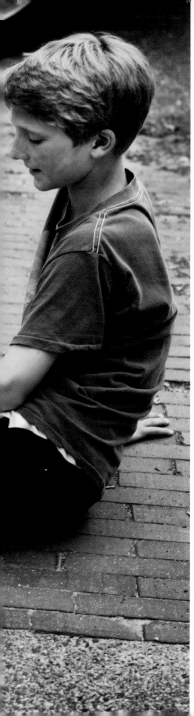

5I.

It's different with you because when I'm with my brother
I can't see outside of him and me. It's like we're swimming
in the same water all the time. But you're over there trying
to get the baby doll to wake up so we can go tell the queen,
and I don't have to say anything. We just think it the same
and maybe that's better than brothers.

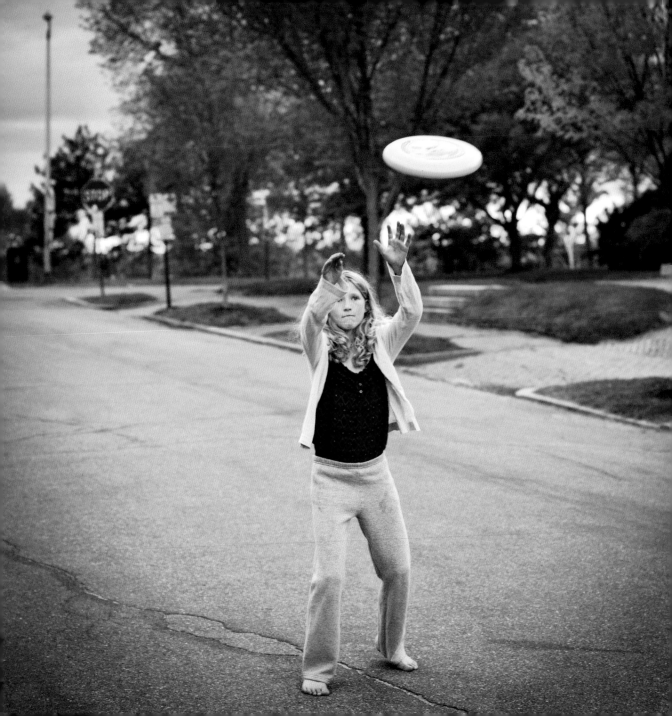

52.

It's the time of day called the gloaming, but I don't know the word

for that yet so it's just sundown when all the boys run in the street,

and I feel like I'll live forever. I mean how could I ever not be here?

We have one street light that blinks, and a long cool crack

in the tar. The boys can be stingy, and I'm mostly the only girl.

When the Frisbee sails down on me like a spaceship,

I know I can catch it. I'm the girl in the picture. I can do this.

ACKNOWLEDGMENTS

WINKY—

It seems that the endless photos I take have just been waiting, patiently, for Susan Conley to speak to them. I cannot thank you enough, Susan, for taking me and my pictures to new places, whether it was my own mother's head or my children's eyes. Each week, often a bit teary, and once even laughing out loud (Aidan and Harry with the baby doll!), your words made me stop, think, and feel . . . which felt so right. Susan, you made the photos so much better. And Maine! We are so lucky to live here, on this street, in this city of Portland, with mountains and islands and water within reach. Alex, thank you for everything. Ben, Harry, and Lo, I am forever grateful to you for allowing my camera to be a natural part of your landscape. I need to take pictures, and you three understand that and let me. And Aidan, Izzy, Thorne, Burr, Charlotte, Lucy, and so many others, thank you for not paying much attention to the camera around my neck. And xo to Bear and Liddy.

SUSAN—

I'm incredibly grateful to Aidan and Harry and Lolie, who approved every page of their book and made this project one of the most fun things I've ever done. Thank you too, to each child who agreed to a cameo. Deepest thanks to Winky Lewis. Lifelong friend. Creative agitator. Wise woman with camera. I am indebted to her for taking the risk with me each week and for letting the stories go where they went. This is Monty Lewis's brilliant vision, and there is no book without his incredible design. Big thanks too, to my husband, Tony, for everything. Always. And to Thorne Kieffer, the brother who chose not to be on these pages, but who inspires every word in the book too. I'm grateful also to my home state of Maine, where so many people I know—writers, artists, educators, work to let the stories of the children in the state be heard, and where sometimes on an endless July day, we can still stop time.

And finally a joint thank you to Down East Books and Michael Steere and the whole Down East team for understanding this hybrid project from the start. It feels so good to have such a great Maine-based publisher for this project.